# DALI

With an introduction by J. G. Ballard
Edited by David Larkin

Pan Books   London

This edition published 1974 by
Pan Books Limited
33 Tothill Street
London S.W.1

ISBN 0 330 23914 7
We are most grateful to the private collectors and
museums who have kindly allowed the use of material in their
copyright.
Printed in Italy by Mondadori. Verona

'The specialised sciences of our times are concentrating on the study of the three constants of life: the sexual instinct, the sentiment of death, and the anguish of space-time.'

SALVADOR DALI, IN 'DALI,' HARRY N. ABRAMS, INC., NEW YORK, 1968.

The uneasy marriage of reason and nightmare which has dominated the 20th century has given birth to an increasingly surreal world. More and more, we see that the events of our own times make sense in terms of surrealism rather than in any other view—whether the grim facts of the death-camps, Hiroshima and Viet Nam, or our far more ambiguous unease at organ transplant surgery and the extra-uterine foetus, the confusions of the media landscape with its emphasis on the glossy, lurid and bizarre, its hunger for the irrational and sensational. The art of Salvador Dali, an extreme metaphor at a time when only the extreme will do, constitutes a body of prophecy about ourselves unequalled in accuracy since Freud's 'Civilisation and its Discontents.' Voyeurism, self-disgust, the infantile basis of our fears and longings, and our need to pursue our own psychopathologies as a game—these diseases of the psyche Dali has diagnosed with dismaying accuracy. His paintings not only anticipate the psychic crisis which produced

our glaucous paradise, but document the uncertain pleasures of living within it. The great twin leitmotifs of the 20th century—sex and paranoia—preside over his life, as over ours.

Painter, writer, engraver, illustrator, jeweller, personality—Dali's polymath genius is on a par with Leonardo's. With Max Ernst and William Burroughs he forms a trinity of men of genius prepared to place their art at the total disposal of the unconscious. However, where Ernst and Burroughs transmit their reports at midnight from the dark causeways of our spinal columns, Dali has chosen to face all the chimeras of our minds in the full glare of noon. Again, unlike Ernst and Burroughs, whose reclusive personalities merge into the shadows around them, Dali's identity remains entirely his own. Don Quixote in a silk lounge suit, he rides eccentrically across a viscous and overlit desert, protected by nothing more than his furious moustaches.

# 'The quicksands of automatism and dreams vanish upon awakening. But the rocks of the imagination still remain.'

SALVADOR DALI, IN 'THE WORLD OF SALVADOR DALI', MACMILLAN, 1962.

For many people, it goes without saying, Dali has always been far too much his own man. In recent years, after a long period in the wilderness,

surrealism has enjoyed a sudden vogue, but to some extent Dali still remains excluded—thanks, firstly, to the international press, which has always encouraged his exhibitionist antics, and secondly to the puritanical intelligentsia of northern Europe and America, for whom Dali's subject matter, like the excrement he painted in 'The Lugubrious Game', reminds them far too much of all the psychic capitulations of their childhoods.

'At the age of six I wanted to be a cook. At seven I wanted to be Napoleon. And my ambition has been growing steadily ever since.'

SALVADOR DALI, IN 'THE WORLD OF SALVADOR DALI', MACMILLAN, 1962.

Admittedly, Dali's chosen public persona—part clown, part mad muezzin on his phallic tower crying out a hymn of gobbets of psychoanalysis and self-confession, part genius with all its even greater embarrassments—is not one that can be fitted into any handy category. Surprisingly, though, Dali's background was conventional. He was born in Figueras, near Barcelona, on May 11, 1904, the second son of a well-to-do lawyer, and enjoyed a permissive and well-loved childhood populated with indulgent governesses, eccentric art masters, old beggar-women and the like. At art school he developed his precociously brilliant personality, and discovered psychoanalysis.

By this time, the late 1920's, surrealism was already an established art. Chirico, Duchamp and Max Ernst were its elder statesmen. Dali, however, was the first surrealist to accept completely the logic of the Freudian age, and to describe the extraordinary world of the 20th century psyche in terms of the commonplace vocabulary of everday life—telephones, wristwatches, fried eggs, cupboards, beaches. What dis-tinguishes Dali's work, above every-thing else, is the hallucinatory natural-ism of his Renaissance style. For the most part the landscapes of Ernst, Tanguy and Magritte describe im-possible or symbolic worlds—the events within them have 'occurred,' but in a metaphorical sense. The events in Dali's paintings are not far from our ordinary reality.

# After Freud it is the outer world, the world of physics, which will have to be eroticised and quantified.'

SALVADOR DALI, IN 'THE WORLD OF SALVADOR DALI,' MACMILLAN, 1962.

This reflects Dali's total involvement in Freud's view of the unconscious as a narrative stage. Elements from the margins of one's mind—the gestures of minor domestic traffic, movements through doors, a glance across a bal-cony—become transformed into the materials of a bizarre and overlit

drama. The Oedipal conflicts we have carried with us from childhood fuse with the polymorphic landscapes of the present to create a strange and ambiguous future. The contours of a woman's back, the significance of certain rectilinear forms, marry with our memories and desires. The roles of everything are switched. Christopher Columbus comes ashore, having just discovered a young woman's buttocks. A childhood governess still dominates the foreshore of one's life, windows let into her body as in the walls of one's nursery. Later, in the mature Dali, nuclear and fragmentary forms transcribe the postures of the Virgin, tachist explosions illuminate the cosmogony of the H-Bomb, the images of atomic physics are recruited to represent a pietist icon of a Renaissance madonna. Given the extraordinary familiarity of Dali's paintings, it is surprising that so few people seem ever to have looked at them closely. If they remember them at all, it is in some kind of vague and uncomfortable way, which indicates that it is not only Oedipal and other unconscious symbols that frighten us, but any dislocation of our commonplace notions about reality. The latent significance of curvilinear as opposed to rectilinear forms, of soft as opposed to hard geometries, are topics that disturb us as much as any memory of a paternal ogre. Applying Freud's principle, we can see that reason safely rationalises reality for us. Dali pulls the fuses out of this comfortable system. To describe the landscapes of the 20th century, he uses its own techniques, its deliberate neuroticism and self-indulgence. Behind these, however, is an eye as sharp as a surgeon's.

In addition, Dali's technique of photographic realism, and the particular cinematic style he adopted, involve

the spectator too closely for his own comfort. Where Ernst, Magritte and Tanguy relied very much on a traditional narrative space, presenting the subject matter frontally and with a generalised time structure, Dali represents his paintings as if each was a single frame from a movie. Filled with a disquieting light that is more electric than solar, his paintings are like stills from some elegant but unsentimental newsreel filmed inside our heads. Taken together, Dali's work shows a remarkable degree of homogeneity, an unfaltering freshness and power of imagination. Above all, Dali is faithful to his obsessions, holding nothing back, even an occasional slickness or absurdity. Of Dali more than any other painter it can be said that the whole man is present in his art. This honesty marks him out as a true modern. Tracing the development of his paintings, we see that they fall into a number of related groups:

(1) The classic Freudian phase. The trauma of birth, as in 'The Lugubrious Game' and 'The Persistence of Memory,' the irreconcilable melancholy of the exposed embryo. This world of fused beaches and overheated light is that perceived by the isolated child. The nervous surfaces are wounds on the cerebral cortex. The people who populate this earliest period of Dali's surrealism, the Oedipal figures and marooned lovers, are those perceived through the glass of childhood and adolescence. The obsessions are the flaccid penis, excrement, anxiety, the timeless place, the threatening posture, the hallucinatory over-reality of tables and furniture, the disquieting geometry of rooms and stairways.

(2) The metamorphic phase. A poly-perverse period, a free-for-all of image and identity. From this period, which began during the 1930s, come Dali's

obsessions with Hitler (the milky breasts of the Fuehrer compressed by his leather belt) and with Lenin, as in 'Vision of Lenin', who is shown with buttock elongated like an immense sexual salami. Also most of the nightmare paintings, such as 'Autumn Cannabalism', which anticipate not only World War II, but the metamorphic horrors of heart surgery and organ transplants, the interchangeability and dissolving identities of our own bodies.

(3) The religious phase. By the middle-1940s, after such paintings as 'Geopoliticus Child watching the birth of the New Man,' came the end of what might be termed the period of explicit surrealism. For the next twenty years the great themes of Christianity preoccupied Dali, as in 'Christ of St. John of the Cross.' After the small canvasses of the early surrealist period, with their often deserted terrains, Dali embarked on a series of enormous paintings, crowded with incident and detail, such as 'The Oecumenical Council.'

(4) The nuclear phase. Dali's marriage with the age of physics. In addition to his religious preoccupations, Dali was fascinated by new discoveries in atomic physics. Many of his most serene paintings, such as 'Raphaelesque Head Exploding,' date from this recent period. Here the iconography of nuclear physics is used to invest his madonnas and religious heroes with the unseen powers of the universe. The strong element of humor in Dali's appraisal of himself and the world around him—an ironic, perverse but wholly serious commentary—reminds us of the generous and unflagging way in which he has entertained us for almost half a century, and in the face, moreover, of a usually hostile and derisory audience. But his place in the pantheon of master-artists of the 20th century is already secure, reserved

from the moment he completed his first masterpiece, the classic 'Persistence of Memory,' with its soft watches and flaccid embryo expiring on a fused beach. At their best, Dali's paintings reveal in the most powerful form the basic elements of the surrealist imagination: a series of equations for dealing with the extraordinary transformations of our age. Let us salute this unique genius, who has counted for the first time the multiplication tables of obsession, psychopathology and possibility.

'It is not necessary for the public to know whether I am joking or whether I am serious, just as it is not necessary for me to know it myself.'

SALVADOR DALI, IN 'DALI,' HARRY N. ABRAMS, INC., NEW YORK, 1968.

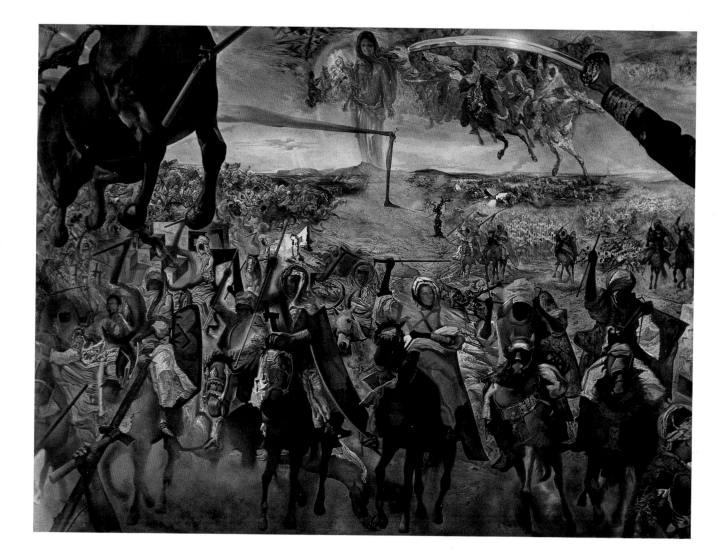

The Battle of Tetuan
1962 HUNTINGTON HARTFORD COLLECTION

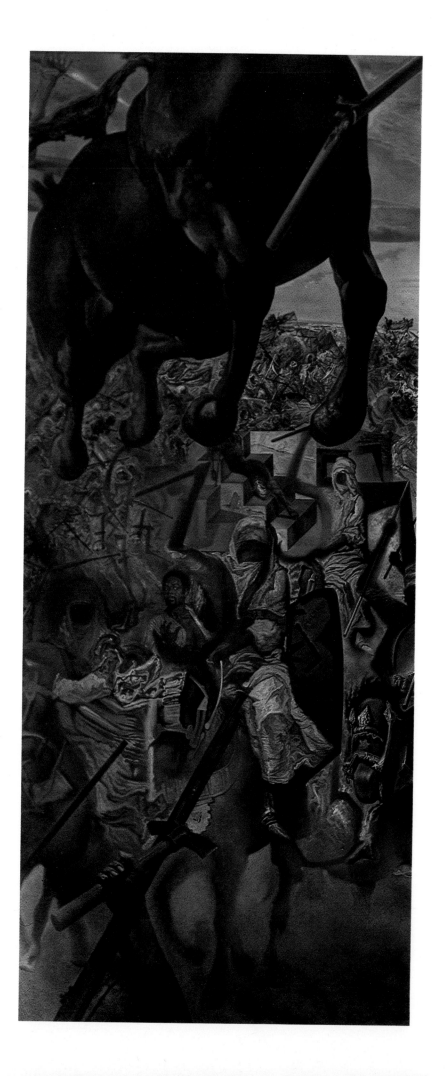

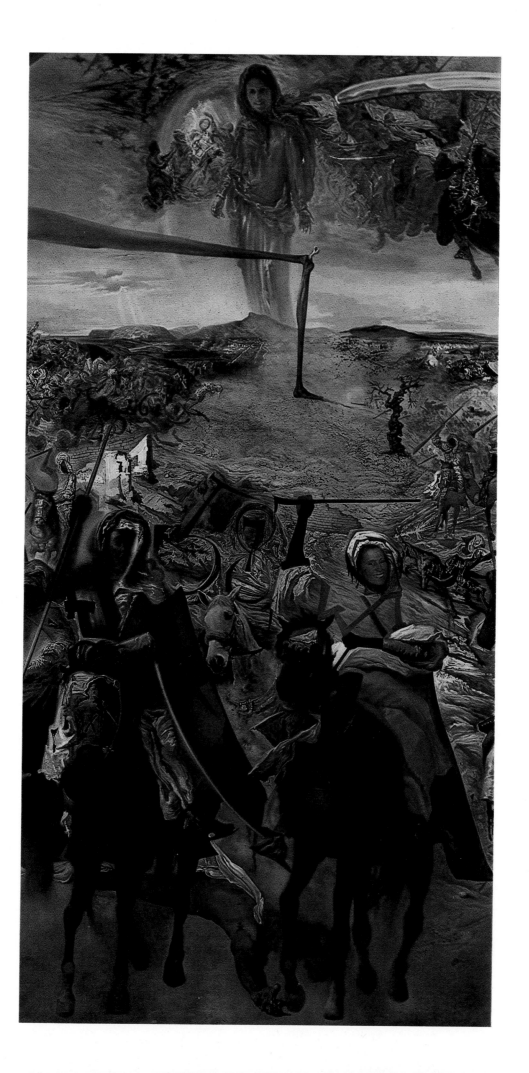

The Battle of Tetuan
1962 HUNTINGTON HARTFORD COLLECTION

Detail

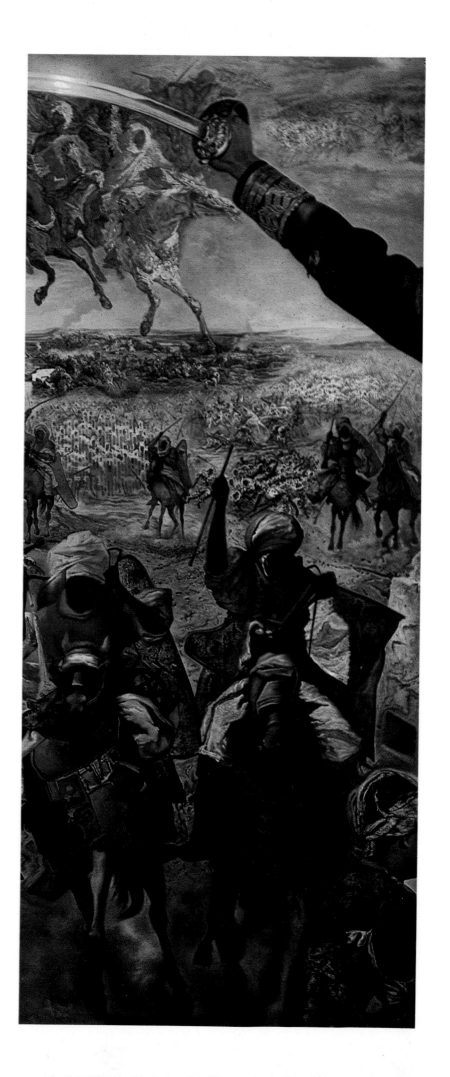

**The Battle of Tetuan**
1962 HUNTINGTON HARTFORD COLLECTION
© by A.D.A.G.P. Paris, 1973

Detail

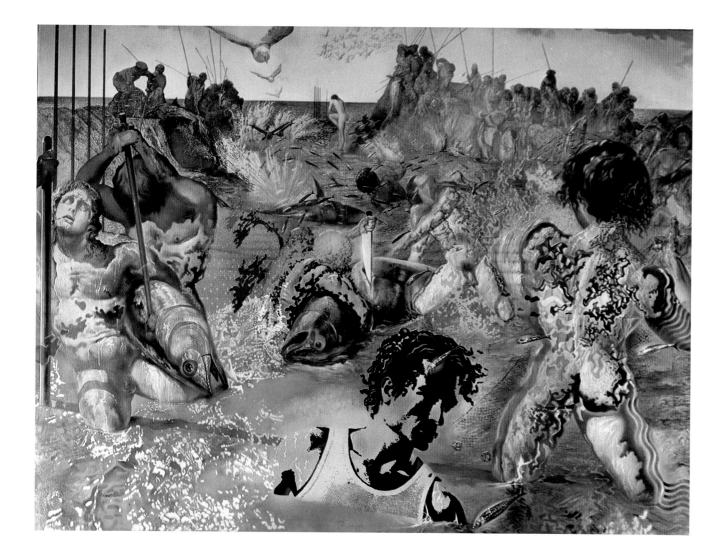

Tuna Fishing
1967-78 PAUL RICHARD COLLECTION
© by A.D.A.G.P. Paris, 1973

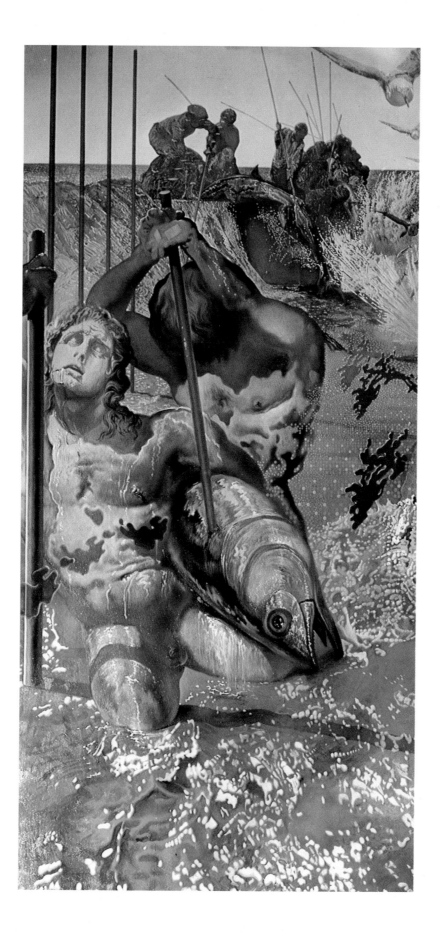

Tuna Fishing
1966-67 PAUL RICHARD COLLECTION
© by A.D.A.G.P. Paris, 1973

Detail

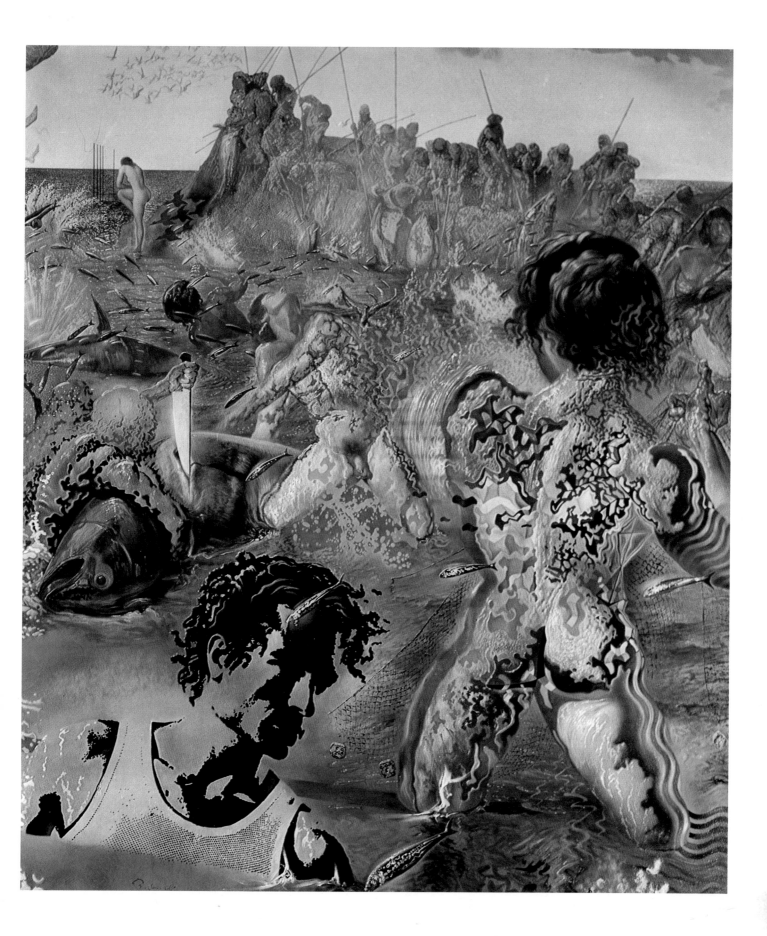

**Tuna Fishing**
1966-67 PAUL RICHARD COLLECTION
© by A.D.A.G.P. Paris, 1973

Detail

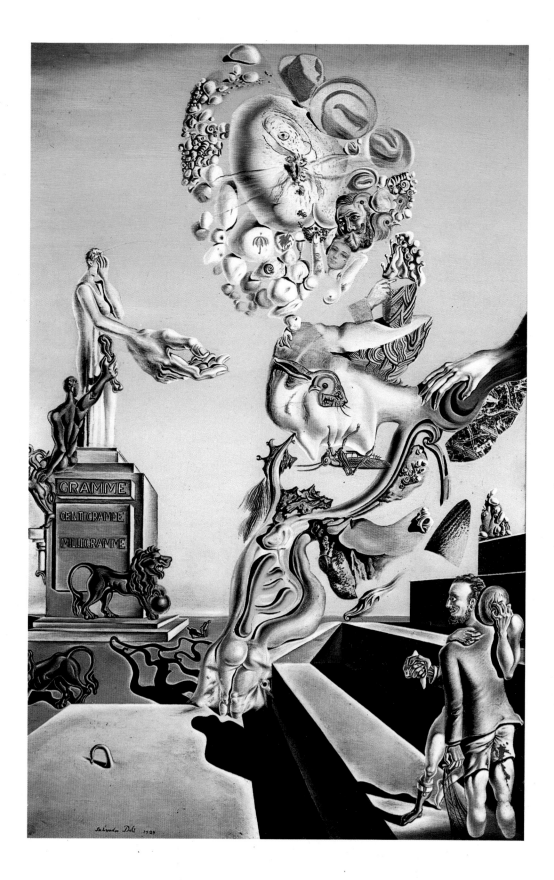

The Lugubrious Game
PRIVATE COLLECTION, PARIS

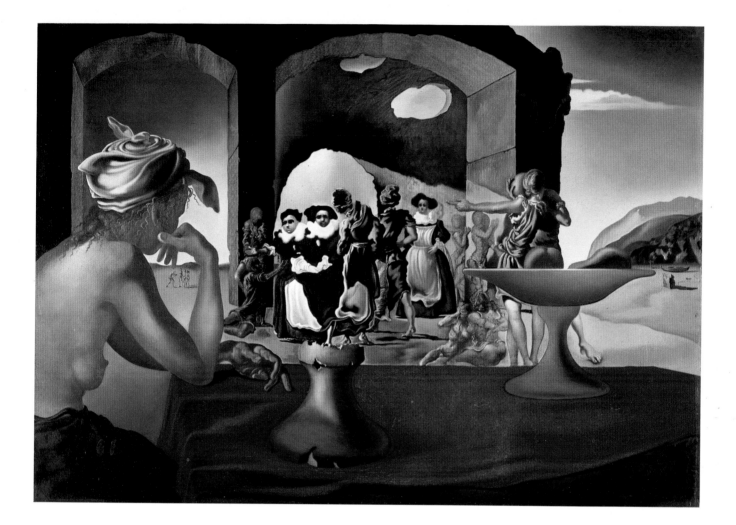

Slave Market with the Apparition
of the Invisible Bust of Voltaire
1940 THE REYNOLDS-MORSE FOUNDATION, CLEVELAND, OHIO

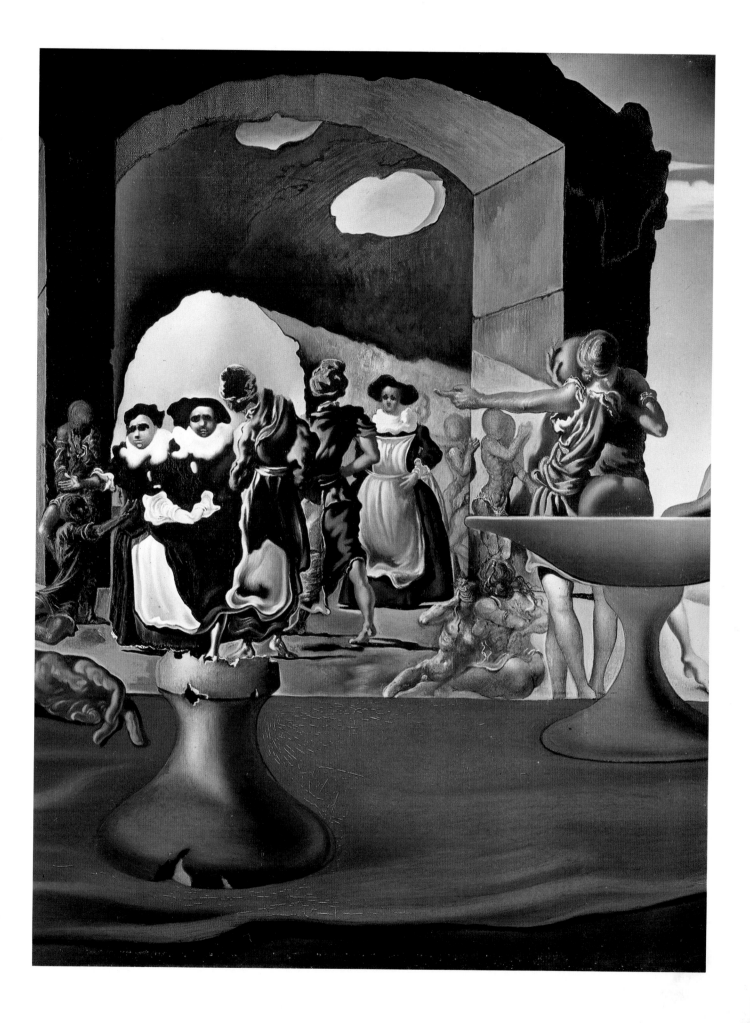

Slave Market with the Apparition
of the Invisible Bust of Voltaire
1940 THE REYNOLDS-MORSE FOUNDATION, CLEVELAND, OHIO

Detail

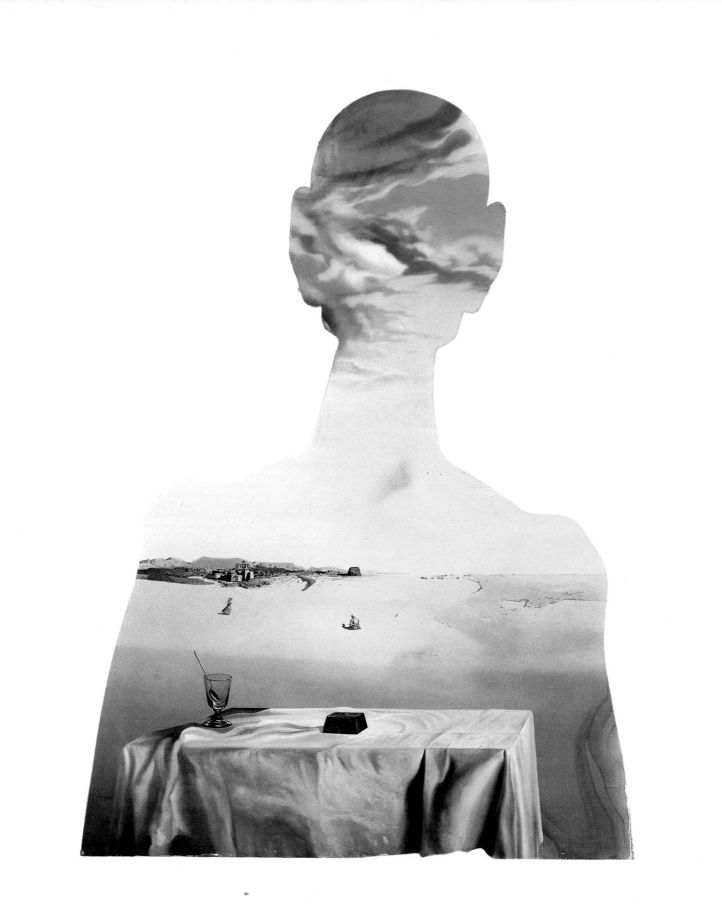

Couple with Clouds in Their Heads
1936 EDWARD JAMES FOUNDATION

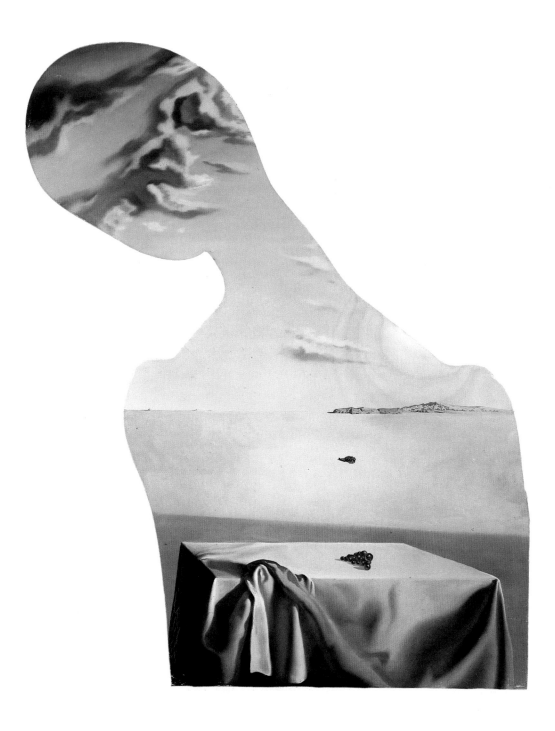

Couple with Clouds in Their Heads
1936 EDWARD JAMES FOUNDATION

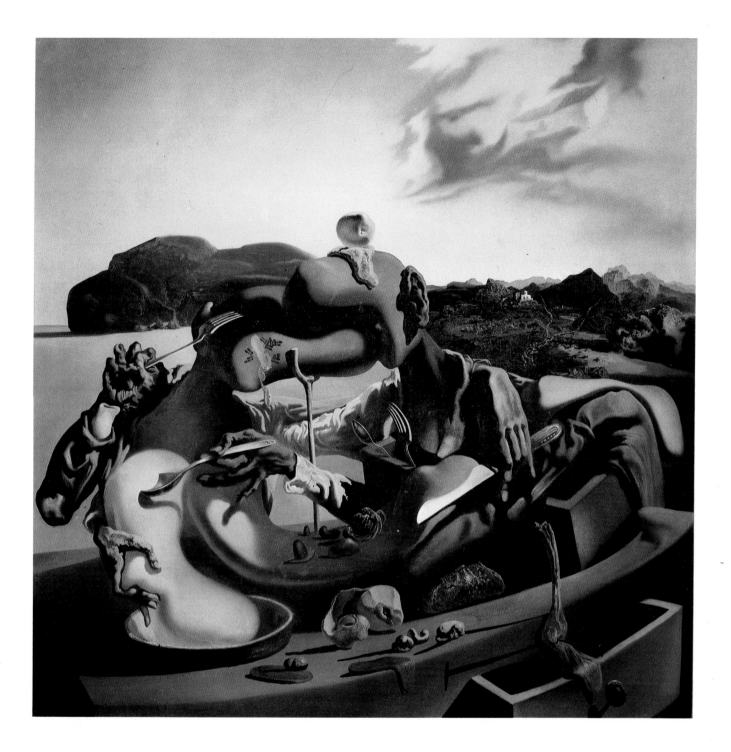

Autumn Cannabalism
1936-37 EDWARD JAMES FOUNDATION

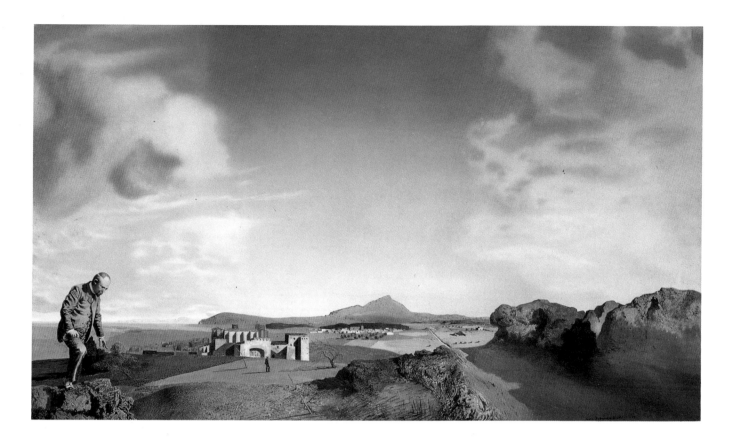

The Pharmacist of Ampurdan Seeking Absolutely Nothing

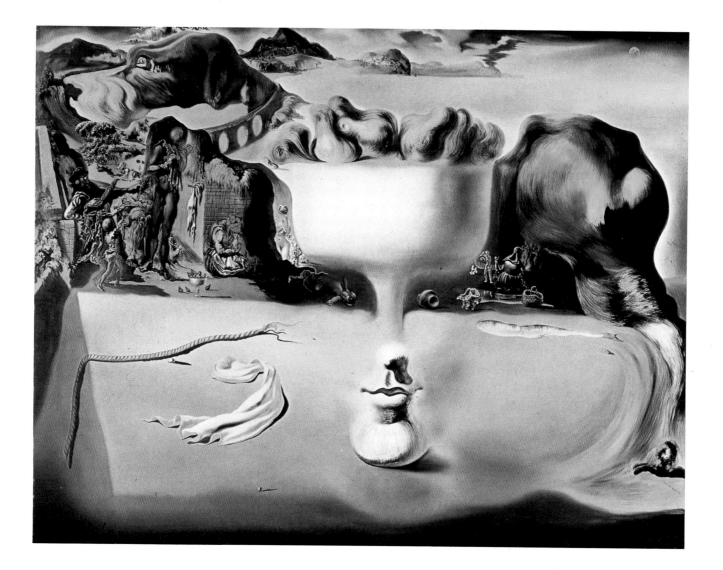

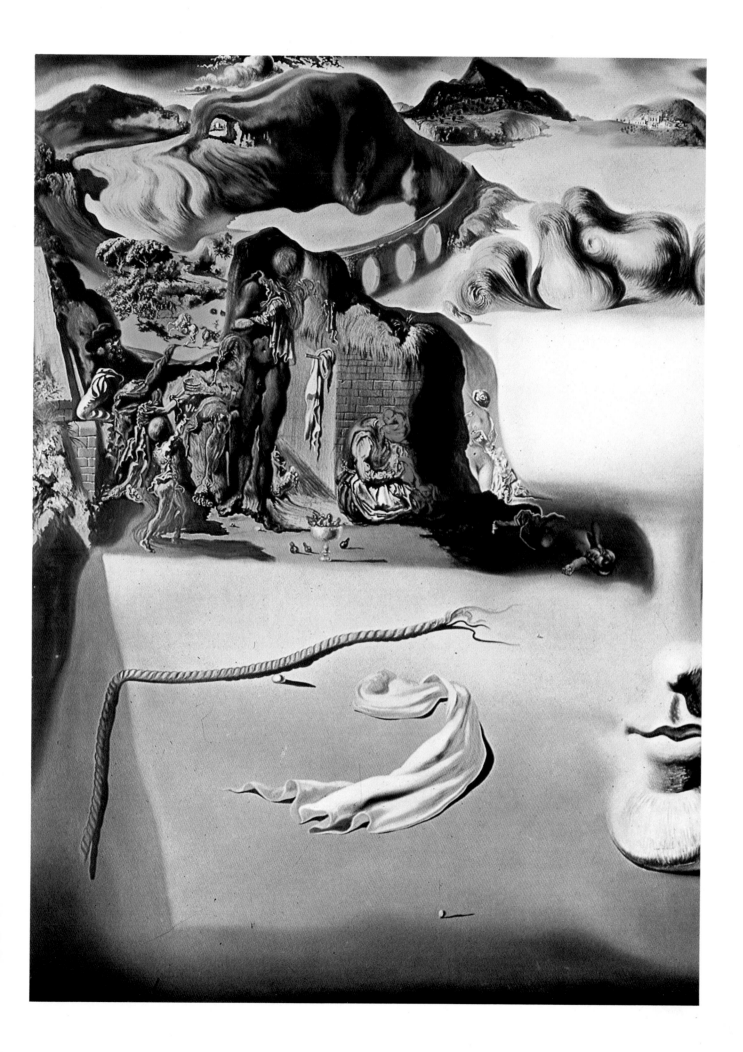

Apparition of Face and Fruit Dish
on a Beach
WADSWORTH ATHENEUM, HARTFORD, CONNECTICUT
© by A.D.A.G.P. Paris, 1973

Detail

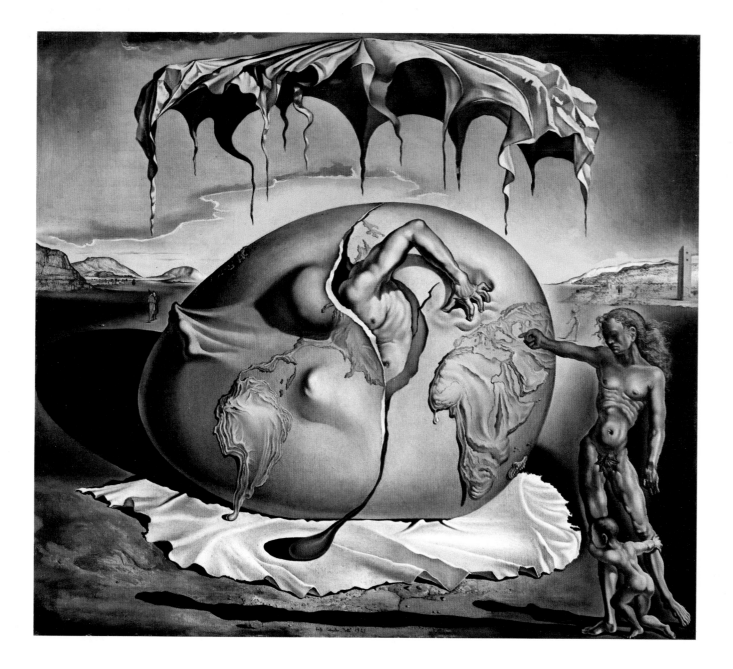

Geopoliticus Child Watching the
Birth of a New Man
1943 REYNOLDS-MORSE COLLECTION, CLEVELAND, OHIO

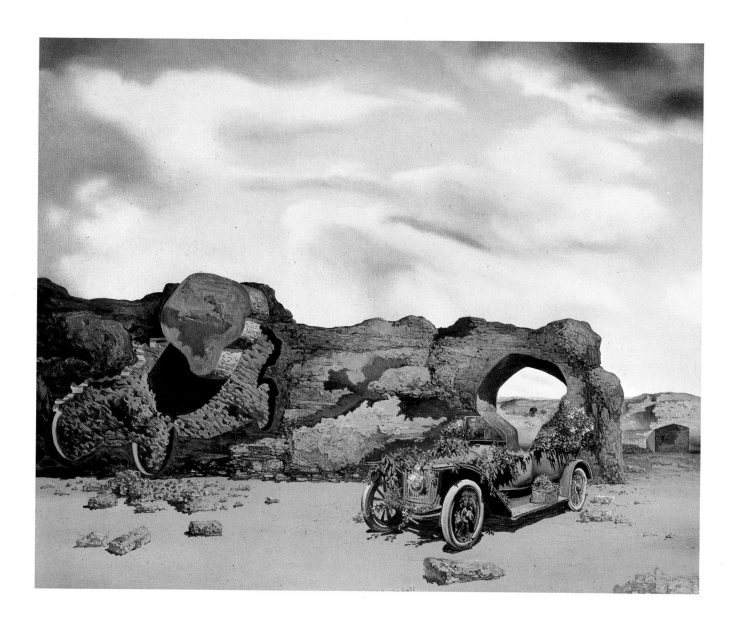

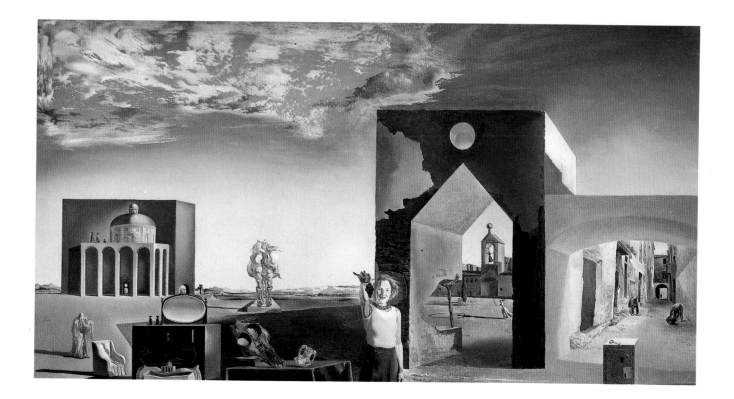

Of Paranoic Critical Town
1936 EDWARD JAMES FOUNDATION

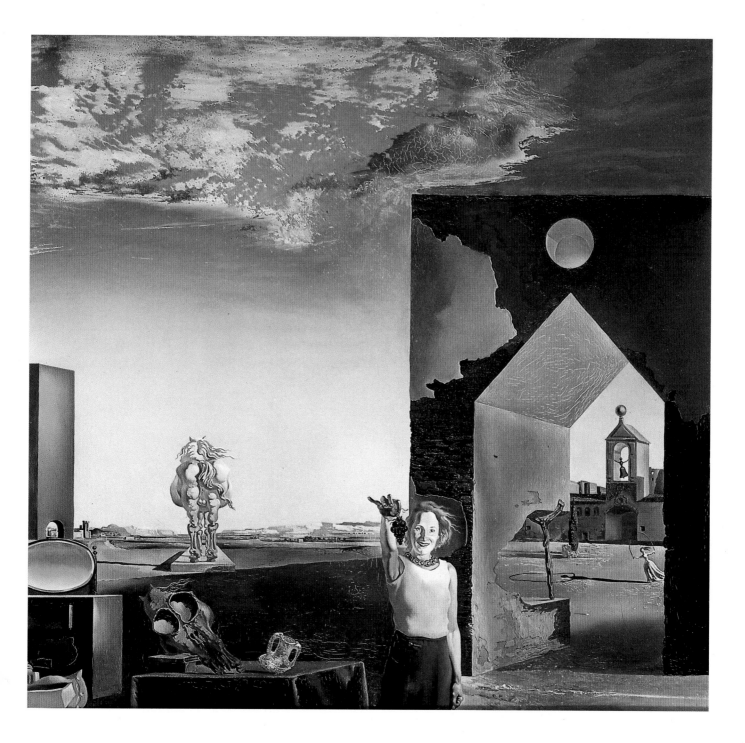

Of Paranoic Critical Town
1936 EDWARD JAMES FOUNDATION

Detail

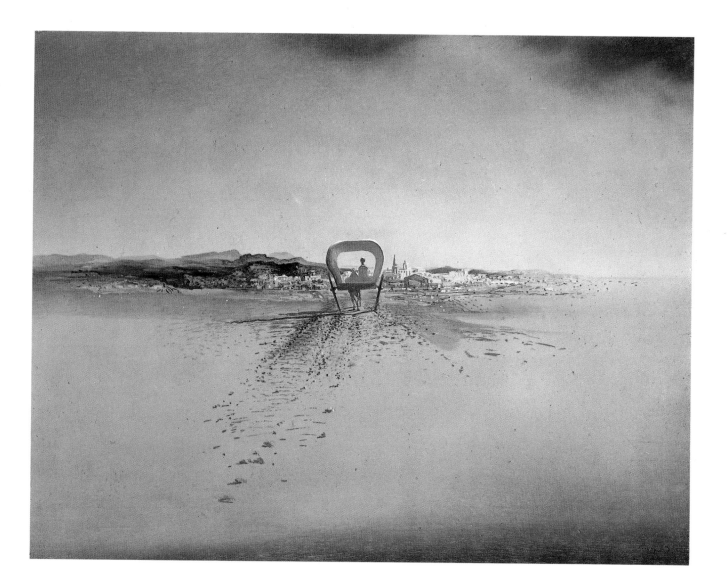

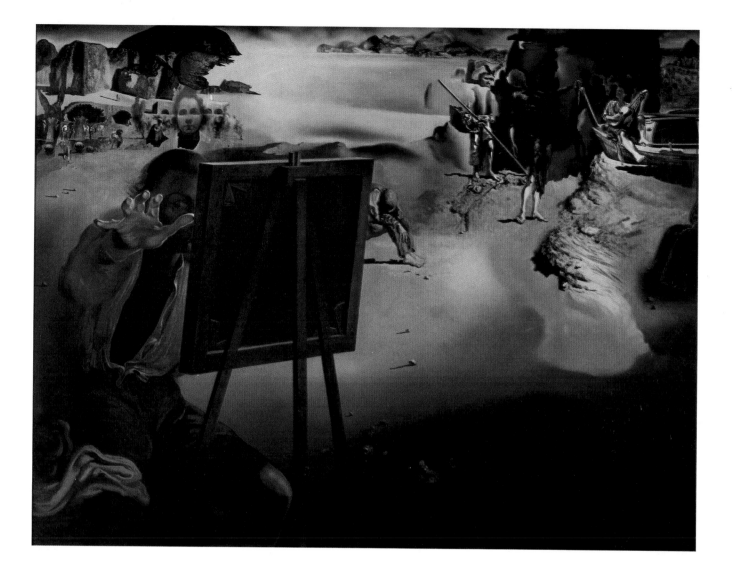

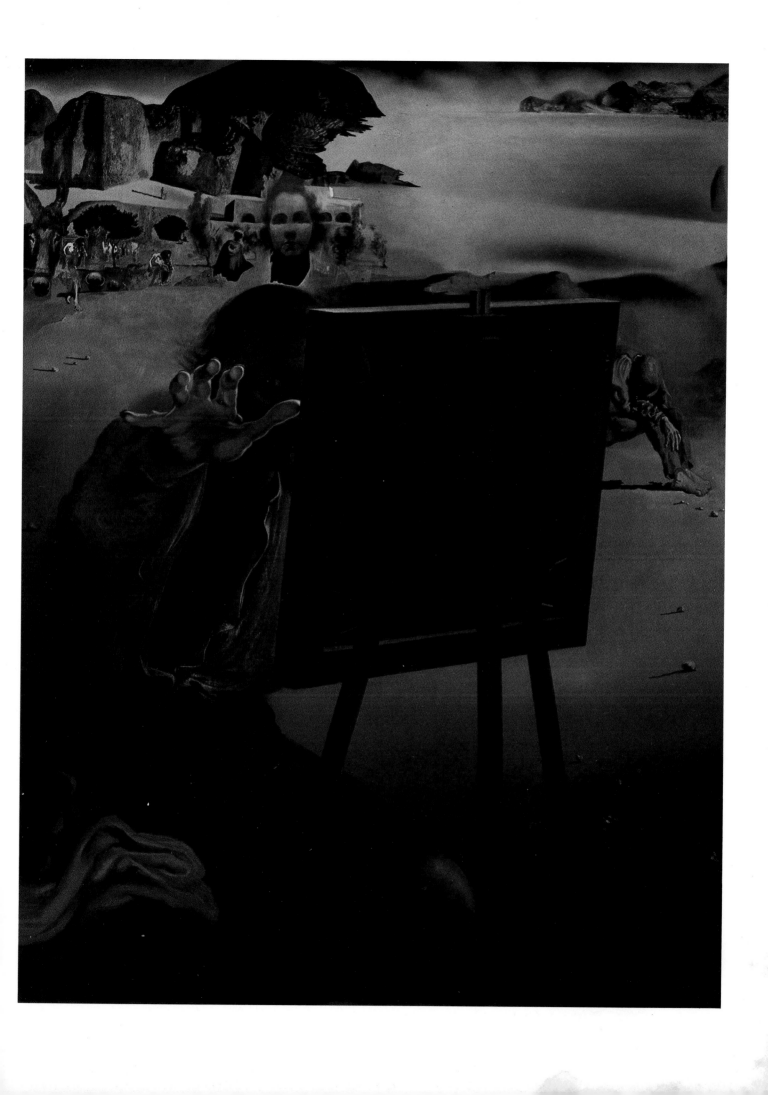

Impressions of Africa
1938-39 EDWARD JAMES FOUNDATION
© by A.D.A.G.P. Paris, 1973

Detail

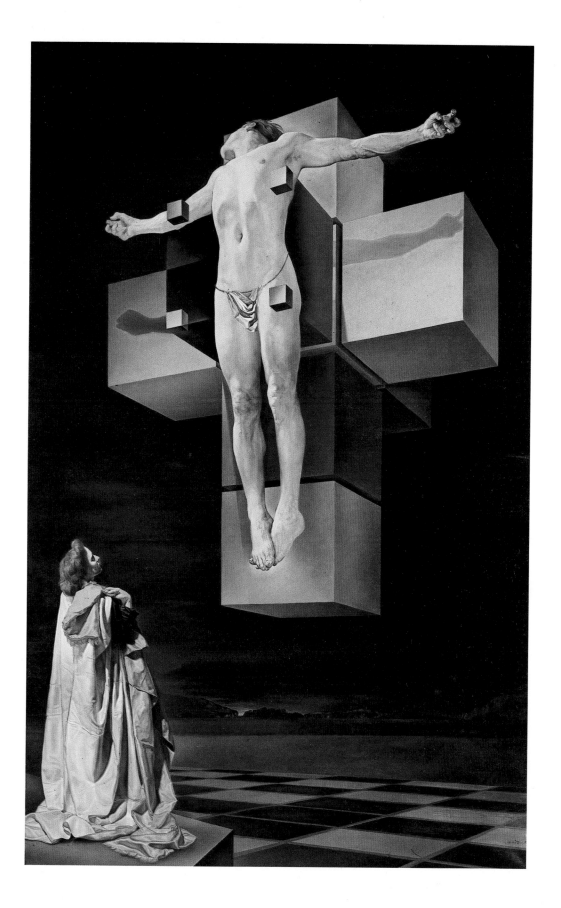

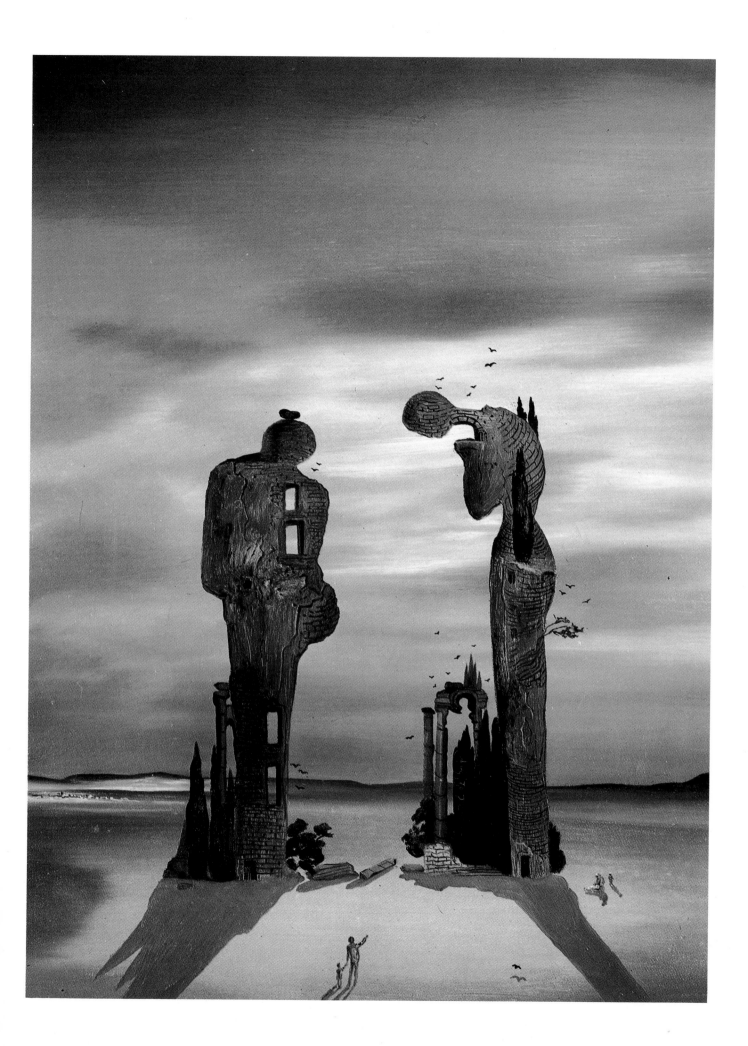

Archeological Reminiscence
of Millet's Angelus
1933

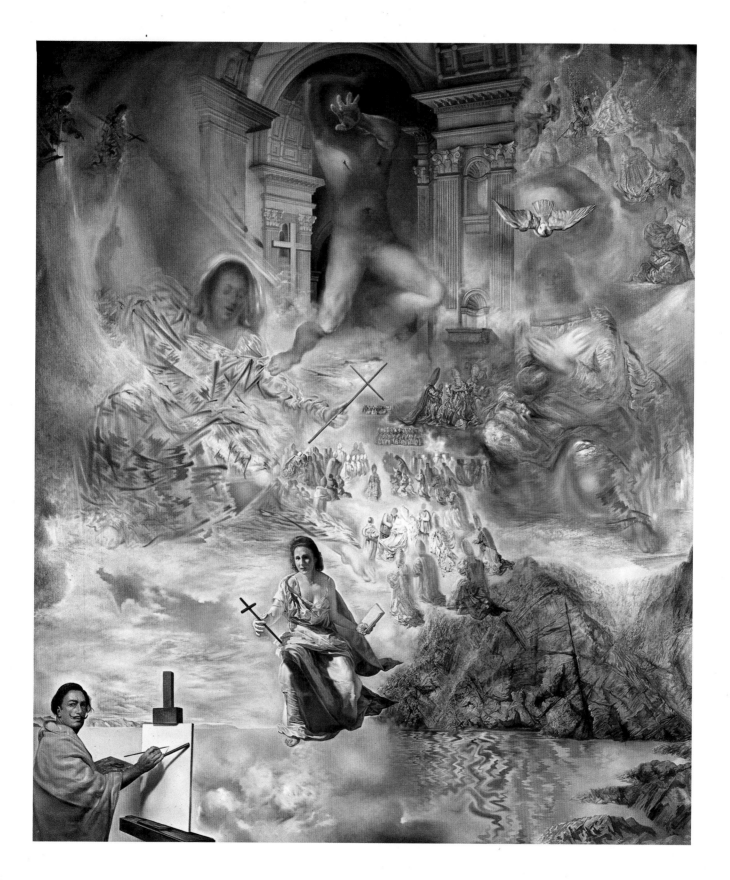

The Oecumenical Council
1960 PRIVATE COLLECTION
ON LOAN TO THE DALI MUSEUM
CLEVELAND, OHIO

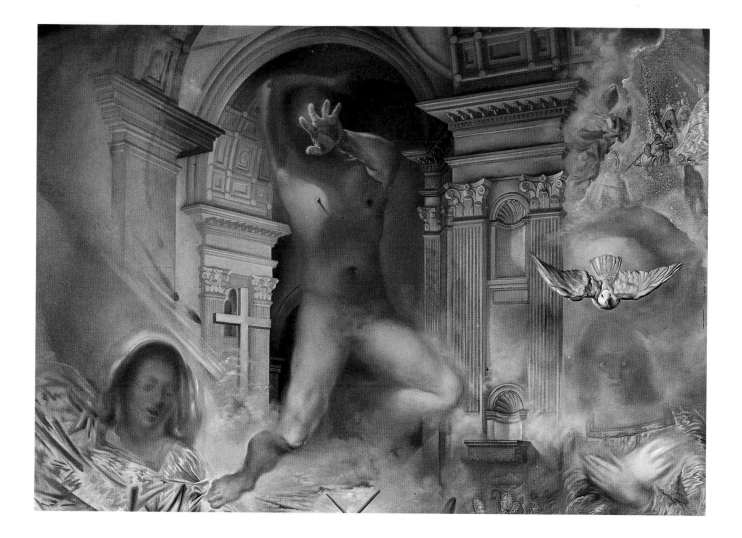

The Oecumenical Council
1960 PRIVATE COLLECTION
ON LOAN TO THE DALI MUSEUM
CLEVELAND, OHIO
© by A.D.A.G.P. Paris, 1973

Detail

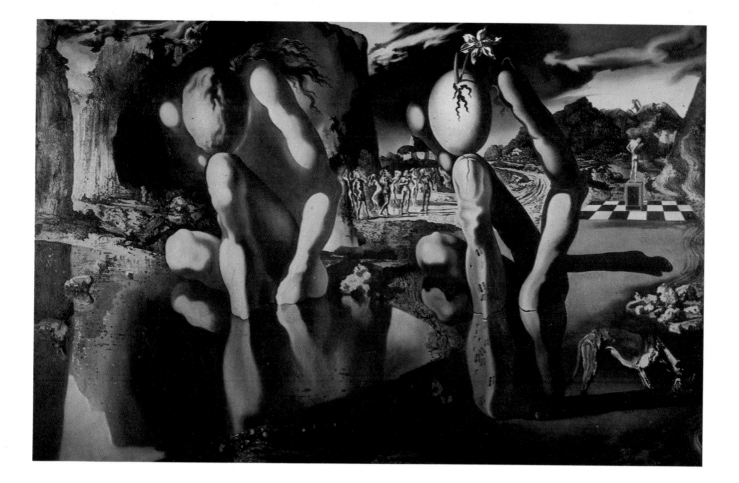

Metamorphosis of Naricssus
1936-37 EDWARD JAMES FOUNDATION

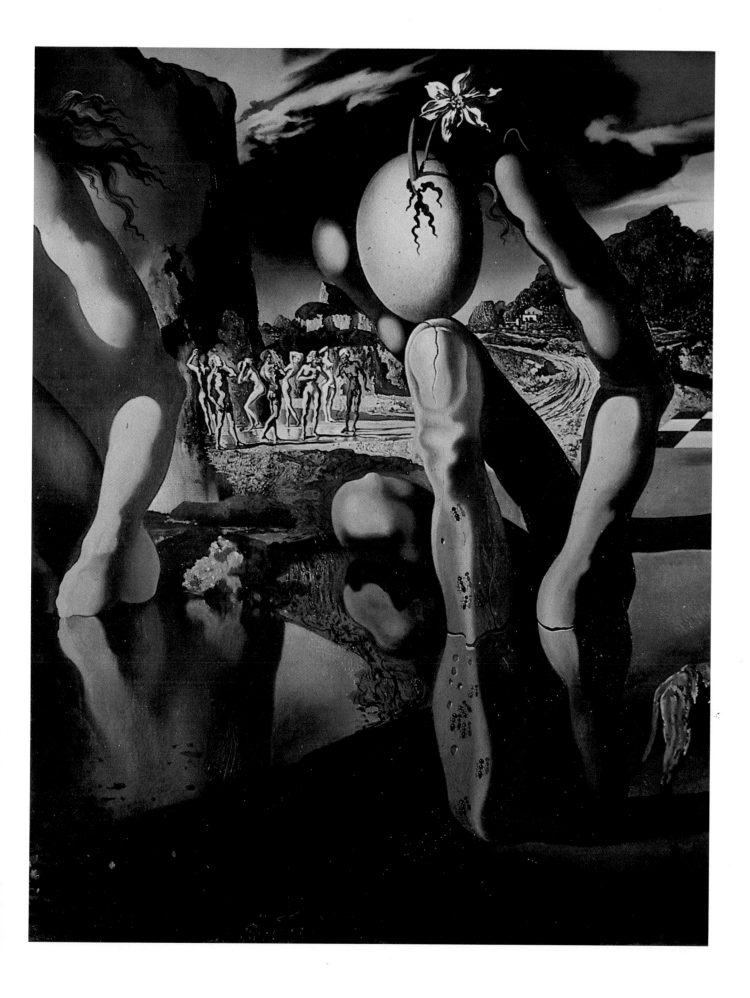

Metamorphosis of Naricssus
1936-37 EDWARD JAMES FOUNDATION

Detail

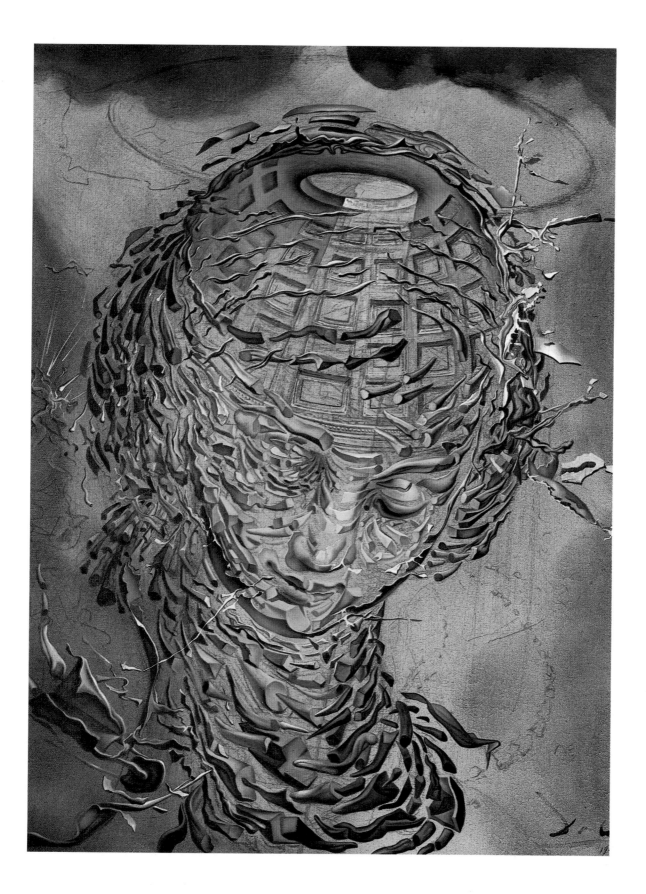

Raphaelesque Head Exploding
1951 PRIVATE COLLECTION, ENGLAND

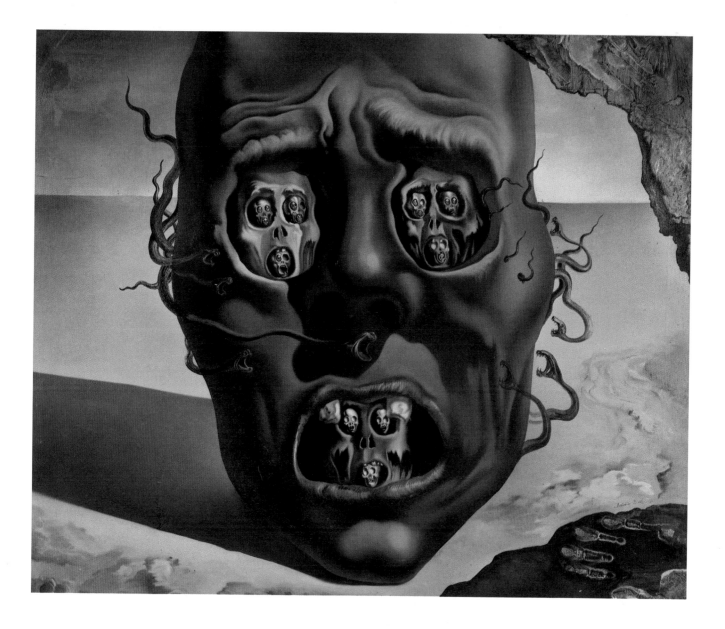

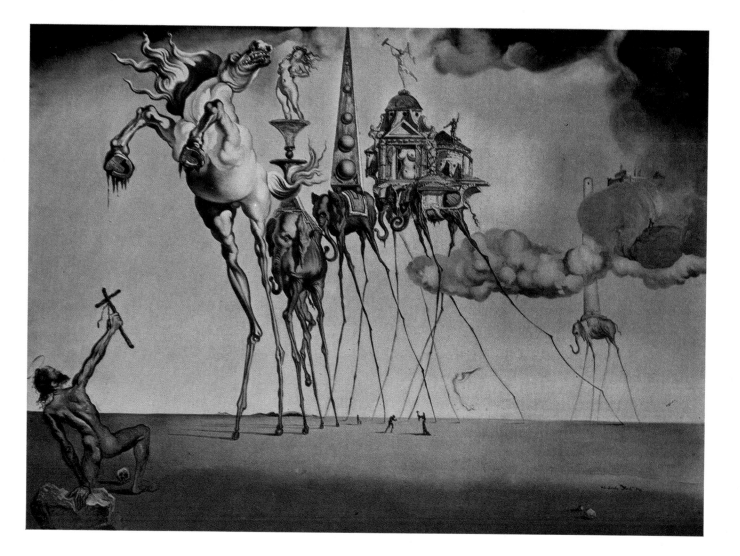

The Temptation of St. Anthony
1946 MUSEES ROYAUX DES BEAUX ARTS, BRUSSELS

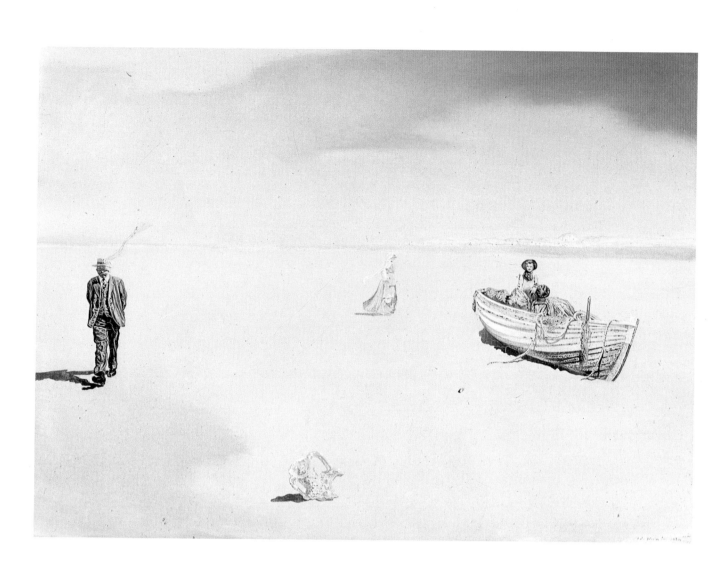

Paranoic Astral Image

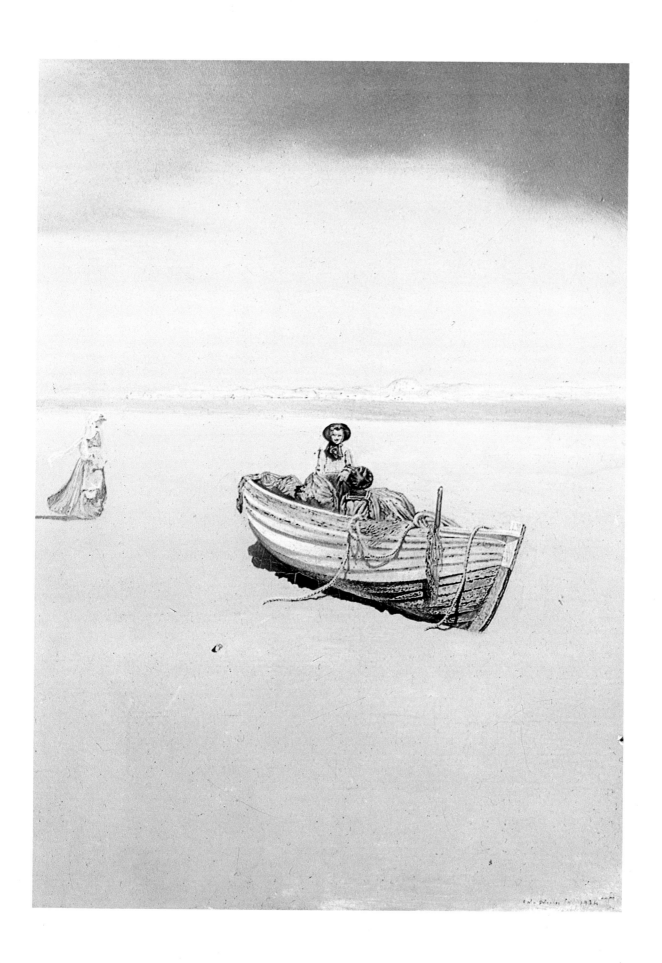

Paranoic Astral Image
1934 THE ELLA GALLUP SUMNER AND
MARY CATLIN SUMNER COLLECTION WADSWORTH ATHENEUM
HARTFORD, CONNECTICUT

Detail

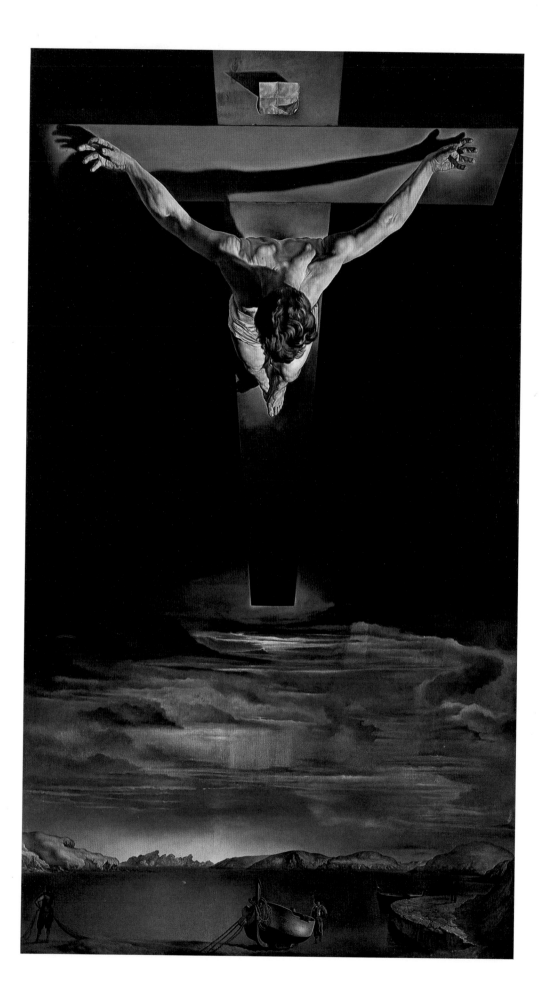

**Crucifixion**

1954 CHESTER DALE COLLECTION
METROPOLITAN MUSEUM OF ART, NEW YORK

© by A.D.A.G.P. Paris, 1973

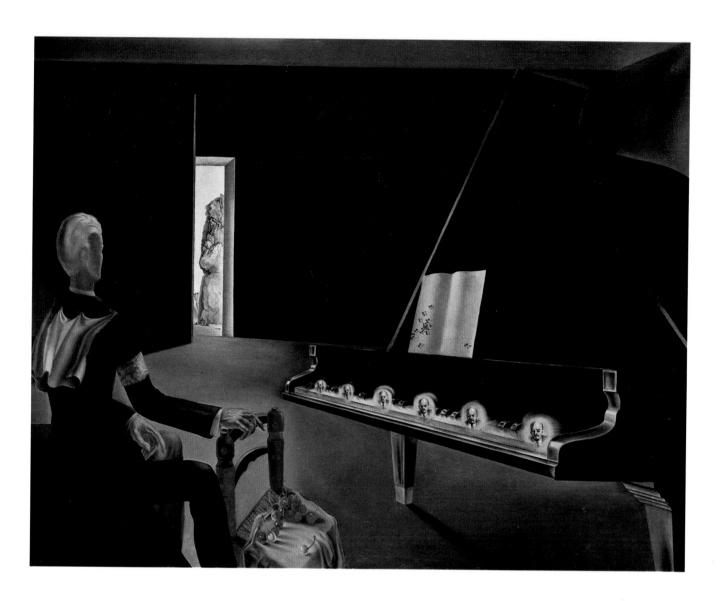

Composition: Evocation of Lenin
1931 MUSEE NATIONAL D'ART MODERNE, PARIS

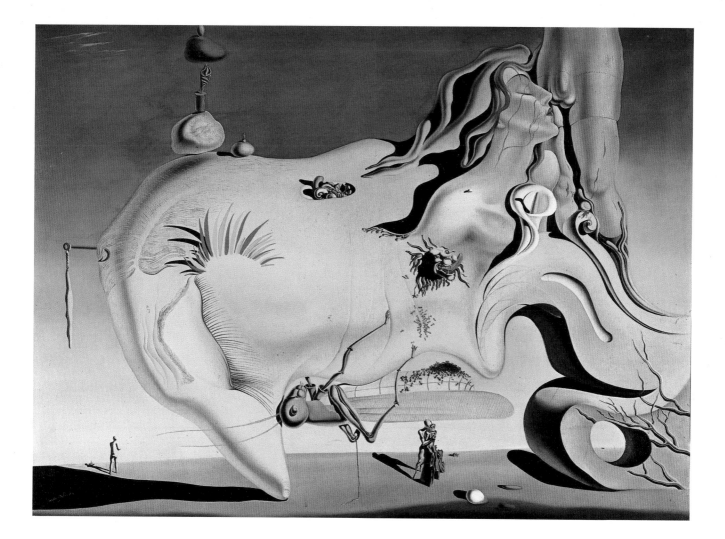

The Great Masturbator
1929 PRIVATE COLLECTION, PARIS
© by A.D.A.G.P. Paris, 1973

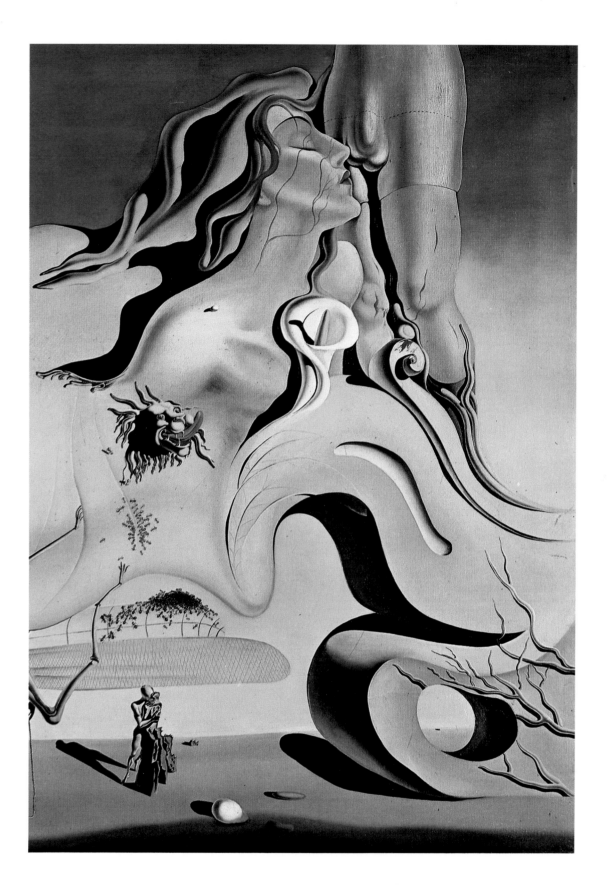

The Great Masturbator
1929 PRIVATE COLLECTION, PARIS
© by A.D.A.G.P. Paris, 1973

Detail

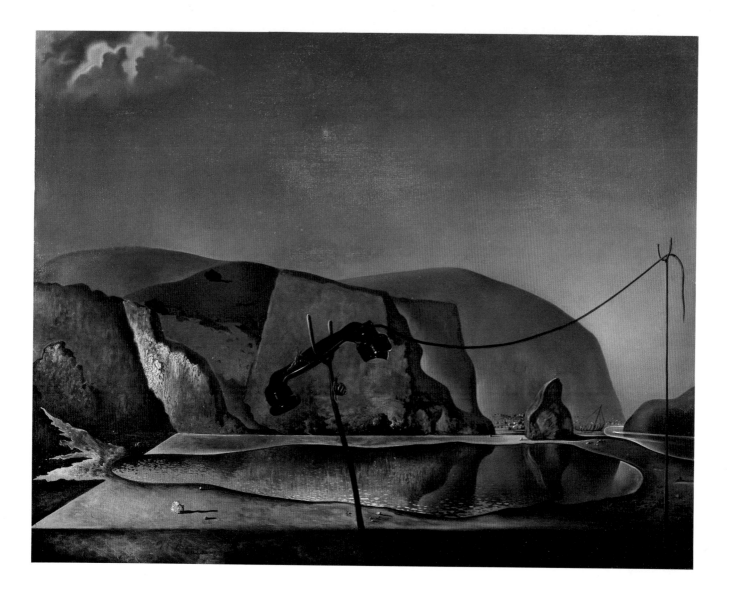

Beach Scene with Telephone
1938 EDWARD JAMES FOUNDATION

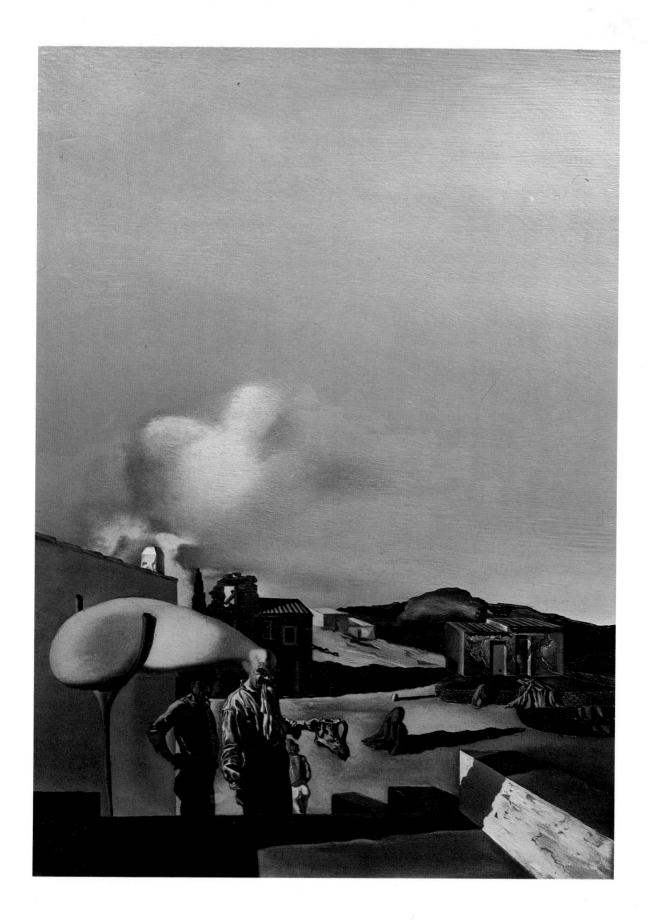

The Average Fine and Invisible Harp
PRIVATE COLLECTION, PARIS